HOLLYWOOD DOGS

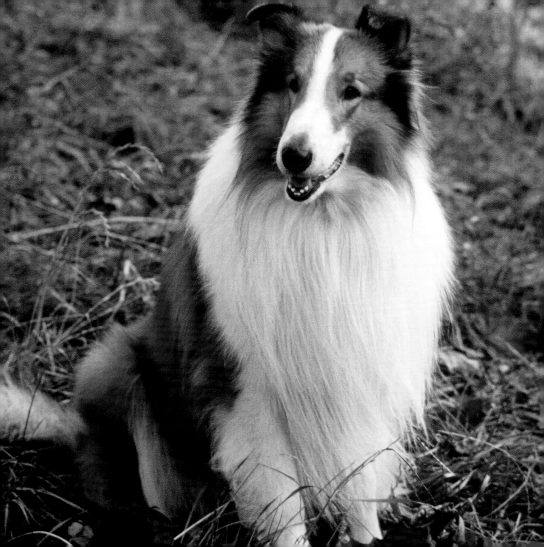

HOLLYWOOD DOGS

Ann Lloyd

BARRON'S

INTRODUCTION

In the beginning…

Dogs have starred in Hollywood movies since the pioneering days of filmmaking. They are the unsung heroes of the big screen who have given us some of our most memorable movie moments, and will always hold a special place in our hearts. From their earliest onscreen appearances, the dog's main role has been clear—to be "Man's Best Friend." The damsel in distress, the courageous hero, or the brave, struggling family can always rely on their four-footed comrade to fend off the wolves, scare away the criminals, rescue the baby, or just be waiting to welcome them home.

The earliest canine stars, such as Teddy the Labrador cross who worked on dozens of silent movies for Mack Sennett's Keystone Company, came under the props department. The first "name-above-the title" dogs, complete with their own agents, fan clubs, and press conferences, were Strongheart, Flash, Rin Tin

Tin, and the biggest superstar of them all, Lassie. Their uplifting adventures, in which they portrayed all the most laudable qualities of dog *and* man, became matinee fare for decades to come.

Star grooming
Life has been a rags to riches story for most of Hollywood's canine stars. Many are strays rescued from surrounding animal shelters and groomed for stardom. To become dog actors, they have to be highly trained—looking cute and lovable just isn't enough. For training to be successful, a dog needs a lively and outgoing personality, but must also be obedient, intelligent, and a fast learner. Once on set, the dogs have to give their trainers their full attention, regardless of the many distractions going on around them, and they have to obey their commands the first time they are given (there is seldom a second chance during filming).

Some of the first and best animal trainers became celebrities in their own right. The famous Weatherwax family of five dog-training brothers discovered, owned, and trained such canine

stars as Lassie, Asta from *The Thin Man* series, Spike from *Old Yeller*, and Rommy from *Reap the Wild Wind*. Carl Spitz became famous as the owner of Terry, who played Toto in *The Wizard of Oz*, and renowned animal trainer Frank Inn was honored for his work with rescue shelter mutts, such as Higgins, who played "America's most huggable hero," Benji.

The best actor in Hollywood

In the early days of filmmaking, animals were often poorly treated, and they didn't get the recognition they deserved. Today, they are appreciated for being the stars that they are and are treated accordingly. The great actor Humphrey Bogart once famously declared dog-actor Rommy to be "the best actor in Hollywood," which is quite a recommendation! The American Humane Association (AHA) now carefully monitors all Hollywood movies with animal cast members. The ground rules are so specific that the animals are often observed to be having a far better time than the human cast.

In the 1950s, the AHA began awarding animal "Oscars", called PATSY (Picture Animal Top Star of the Year) Awards, in

recognition of animal stars of the big and small screens. Early canine winners included Sam, who starred with John Wayne in *Hondo* in 1953, and Spike of *Old Yeller* fame in 1958.

A good dog never dies

Today, dogs are bigger movie stars than ever, with Beethoven, Hooch, Lou the Beagle, and the *101 Dalmatians* pups finding their way into our hearts. Their roles may have shifted to that of police dog (*K9, Turner and Hooch*), sports star (*Air Bud*), or even talking alien (*Men in Black*), but Hollywood Dogs still know how to tug at our heartstrings and make us laugh. Whether they are talking aliens, reincarnated humans, dog detectives, or secret agents out to prevent cats from taking over the world, their primary mission is always clear—to help and protect mankind. They are our faithful friends, prime comforters, loyal travel companions, and saviors, and they can always be relied upon to find their way home. We enter the movie theater knowing that, whatever happens, the classic dog movie will end "happily ever after" because, after all, a good dog never dies.

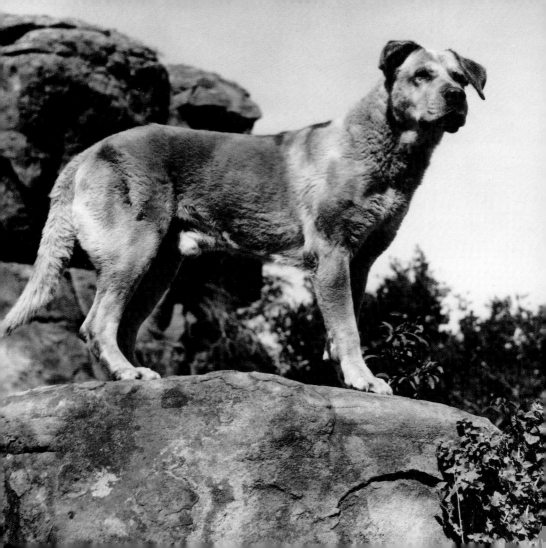

> **With eye uprais'd, his master's looks to scan,**
> **The joy, the solace, and the aid of man:**
> **The rich man's guardian, and the poor man's friend,**
> **The only being faithful to the end.**
>
> George Crabbe

OLD YELLER
Dir. Robert Stevenson (1957)

For the tiny sum of three dollars, renowned animal trainer Frank Weatherwax rescued Spike—a large, lop-eared, huge-footed, yellow pup—from an animal shelter. Spike wasn't an obvious actor, and it took a lot of training to refine his clumsy movements and turn his yelp into a macho bark. Nevertheless, he won the role of Old Yeller—the tough stray who becomes beloved friend and protector of a Texas family. Walt Disney was originally unsure if the friendly mutt would be able to play the scenes where Old Yeller turns vicious, but his trust in Spike was rewarded by the movie's incredible success as it moved into the U.S. Box Office Top Ten.

AGENT J: Lose the Suit!

FRANK THE PUG: Sure thing partner. No problemo. Just going for the look. But, if I say so myself, I do find the overall effect very slimming!

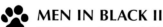 **MEN IN BLACK II**
Dir. Barry Sonnenfeld (2002)

Talking alien-dog Frank the Pug is played by animal actor Mushu, who was chosen for the role because director Barry Sonnenfeld thought "he looked like an alien. He's sort of ugly and strange, and certainly not cuddly." Mushu is the same dog that starred in the first movie but, because he had aged by several years by the time this sequel was made, the filmmakers had to use makeup to hide the gray fur that was starting to grow around his nose.

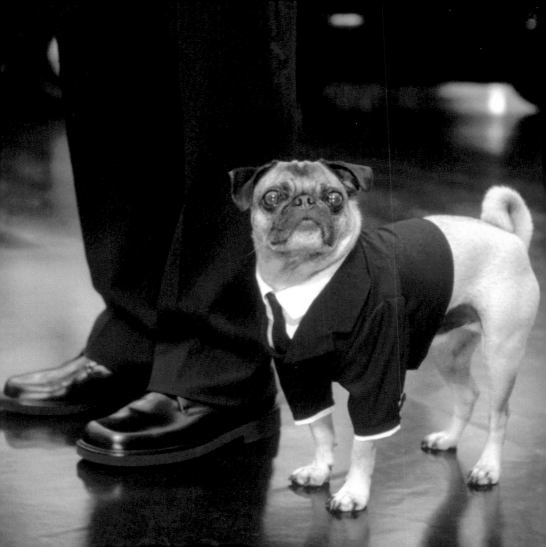

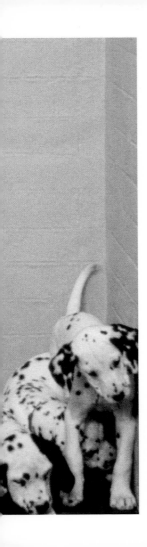

CRUELLA DE VIL: You beasts! But I'm not beaten yet. You've won the battle, but I'm about to win the wardrobe. My spotty puppy coat is in plain sight and leaving tracks. In a moment I'll have what I came for, while all of you will end up as sausage meat... Cruella De Vil has the last laugh!

 ### 102 DALMATIANS
Dir. Kevin Lima (2000)

Head animal trainer Gary Gero, who led the huge team of animal experts involved in the making of *102 Dalmatians*, supervised the training of 230 Dalmatian puppies. The puppies grew so quickly that a fresh batch had to be chauffeured in from accredited Dalmatian breeders every week. Many of the puppies had already been pre-sold and, after their brief movie careers, they went on to their new owners. Many others stole the hearts of the cast and crew and were subsequently adopted.

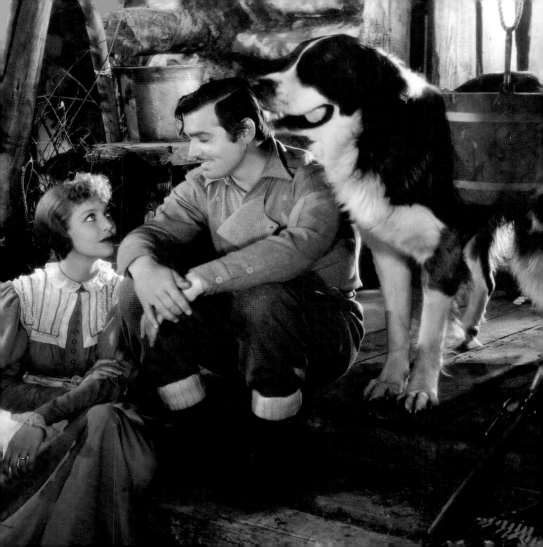

> **Faithfulness and devotion, things born of fire and roof, were his; yet he retained his wildness and wiliness.**
>
> Jack London

 ### THE CALL OF THE WILD
Dir. William A. Wellman (1935)

By the end of the 1930s, animal movies were such big business that the top animal trainers became celebrities in their own right. Carl Spitz, the owner of Buck the St. Bernard from *The Call of the Wild*, was one of these celebrity trainers. In 1940, he embarked on the public appearance circuit, taking with him around $120,000 worth of dogs ($1.6 million in today's market). His entourage included Musty, the Mastiff from *Wild Boys of the Road*, Prince, the Great Dane from *Wuthering Heights*, Mr. Binkie, the Scottie from *The Light That Failed*, and, most famously, Terry, the Cairn Terrier who played Toto in *The Wizard of Oz*.

> **Rambunctious, rumbustious, delinquent dogs become angelic when sitting.**
>
> Dr. Ian Dunbar

 THE LITTLE RASCALS
Dir. Penelope Spheeris (1994)

American Bulldog Petey was one of the most popular members of the mischievous *Little Rascals* gang in this new version of the classic 1930s *Our Gang* comedies. The original Petey was renowned for the trademark black circle around his right eye. The new filmmakers couldn't find another dog with this same characteristic, so they faked it using non-toxic vegetable dye.

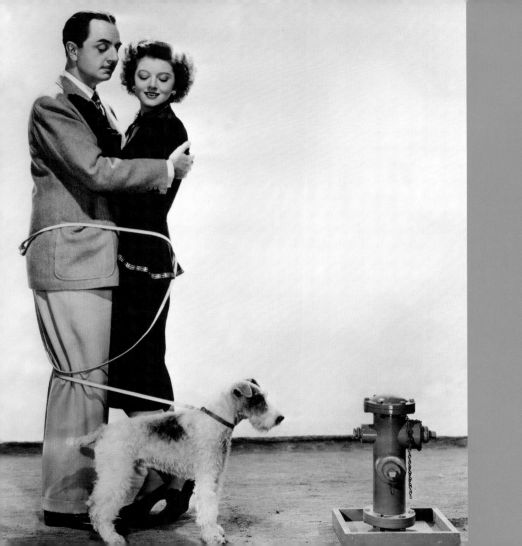

NICK CHARLES: Don't make a move or that dog'll tear you to shreds!

 THE THIN MAN
Dir. W. S. Van Dyke (1934)

As a result of this, the first in a hugely popular comedy-sleuth series starring William Powell and Myrna Loy, their canine co-star Asta became a box-office phenomenon in his own right. Asta was played by Wirehaired Fox Terrier Skippy, who became so well known as Asta that his owners changed his name to that of his most famous role. After the hit series reached television in 1957, Asta won PATSY (Picture Animal Top Star of the Year) Awards in both 1959 and 1960.

SHADOW: Chance, you're a genius!

CHANCE: No, I'm not! Uh, what's a genius?

SHADOW: Never mind.

 ### HOMEWARD BOUND: THE INCREDIBLE JOURNEY
Dir. Duwayne Dunham (1993)

Three pets—a wise old Golden Retriever named Shadow, a brash young American Bulldog named Chance, and an imperious cat named Sassy—set out on a dangerous journey across America to find their way home. For three animal stars, a wealth of trainer trickery and technique was needed. In one scene, when the dogs are taken to the pound, a muzzle is put on Shadow, which could well have distressed the dog. However, not only had he been trained to wear the muzzle and be comfortable with it, he had also been taught how to take it off himself whenever he wished.

> Oh! such a happy, fussy, affectionate, relieved little canine when he saw his beloved owner waiting for him.

J. Hartley Manners

 THE ACCIDENTAL TOURIST
Dir. Lawrence Kasdan (1988)

Geena Davis won the Academy Award for Best Supporting Actress for playing the role of Muriel, the quirky dog handler hired to train a Welsh Corgi named Edward. The Corgi actor's real trainer is Boone Narr, one of Hollywood's leading animal trainers, who is best known for coordinating more than 60 animals for the pet epic *Cats & Dogs*. Narr has won many movie awards over the years, but unlike Davis' Oscar, his are all for real-life animal training.

> **What feeling do we ever find**
> **To equal among human kind**
> **A dog's fidelity!**
>
> Thomas Hardy

 ### GREYFRIARS BOBBY
Dir. Don Chaffey (1961)

This movie is based on the incredible true story of the faithful Skye Terrier, Bobby, who refused to leave his master's side, even after his death. Bobby is the most famous dog in Scotland, and a statue with the inscription "Let his loyalty and devotion be a lesson to us all" has been erected in his honor in Edinburgh. It has become one of the city's most popular tourist attractions.

Meet the two toughest cops in town. One's just a little smarter than the other.

Tagline from the movie

 K-9
Dir. Rod Daniel (1989)

No one wants to be the partner of vice cop Thomas Dooley, played by James Belushi, so he reluctantly settles for police dog K-9. However, the dog quickly proves himself to be an indispensable partner—saving Dooley's life several times and helping him make a huge drug bust. K-9 was played by a real Kansas City police dog named Jerry Lee, who famously discovered 1.2 million dollars worth of cocaine shortly after making the film.

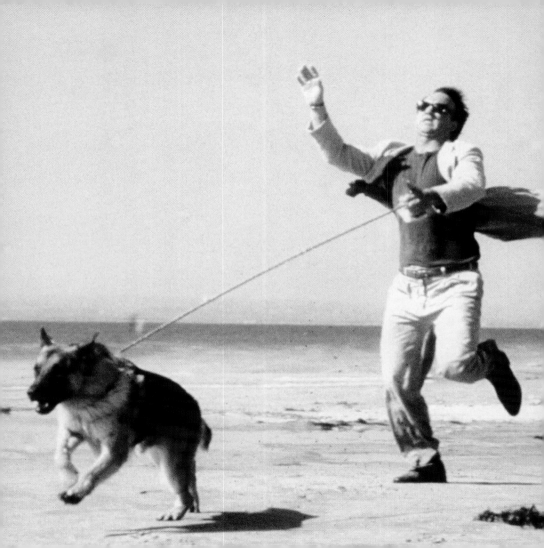

MELVIN UDALL: This is New York, pal. If you can make it here, you can make it anywhere!

 ## AS GOOD AS IT GETS
Dir. James L. Brooks (1997)

A delightful Brussels Griffin dog named Jill is the real star of this modern movie classic. She plays Verdell, the dog who melts dog-hating Melvin Udall's heart and picks up some of his rather idiosyncratic habits along the way. In one scene, she has to copy Melvin by stepping over the cracks in the sidewalk. The filmmakers achieved this by placing little obstacles on the cracks for the dog to jump over and then removing them using digital technology.

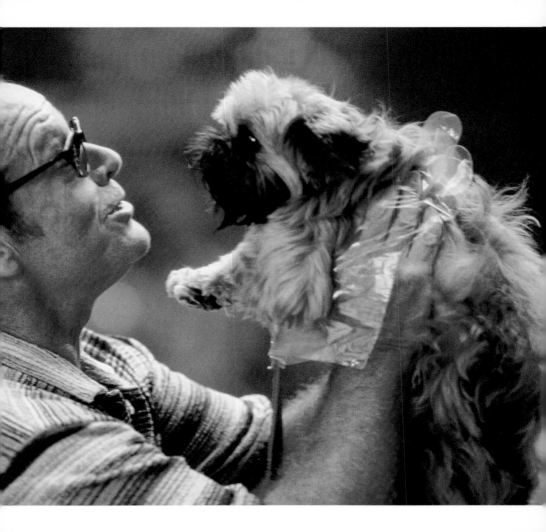

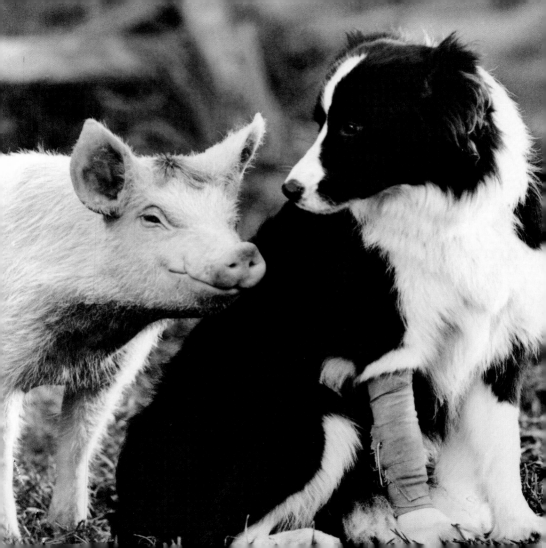

Be a good animal, true to your instincts.

D. H. Lawrence

 BABE
Dir. Chris Noonan (1995)

The animal characters' realistic expressions and emotions were not all created through digital computer animation and animatronics. The animals were so well rehearsed that they were able to "act" their way through the greater part of the script. The lengthy period of pre-production also enabled many members of the four-legged cast to form strong bonds with one another—as is shown, for instance, in the snuggling scenes between Babe and his Collie-mum, Fly.

> # The dog was created specially for children. He is the god of frolic.
> Henry Ward Beecher

 MY DOG SKIP
Dir. Jay Russell (2000)

This movie is a rites-of-passage tale about a boy named Willie Morris (played by Frankie Muniz) and his dog Skip growing up in Mississippi in the 1940s. The older Skip is perfomed by dog-actor Moose, who is most famous for playing Eddie in the TV sitcom *Frasier*. The younger Skip is played by Moose's son Enzo (who also acts as a stand-in for his dad on *Frasier*) and by three other matching Jack Russell Terriers.

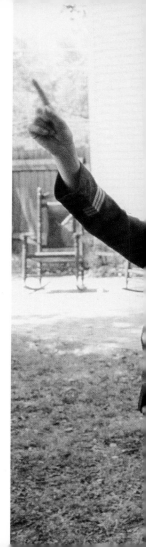

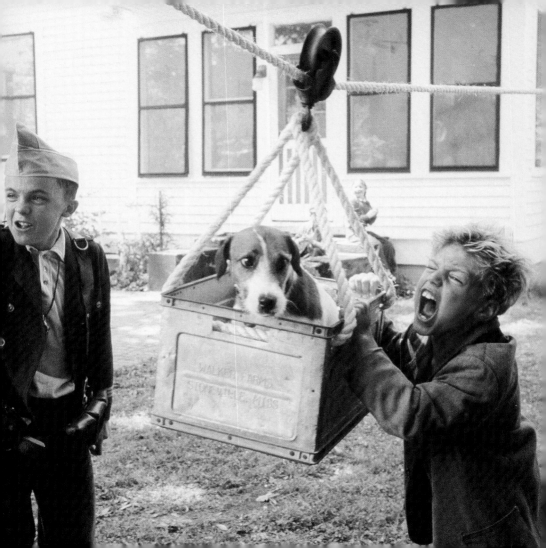

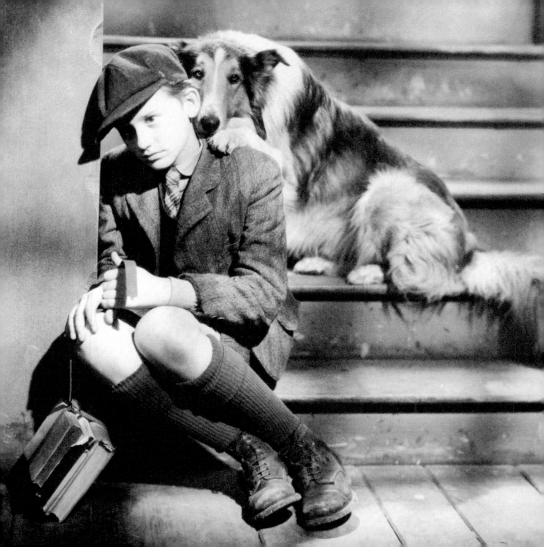

> **One reason a dog can be such a comfort when you're feeling blue is that he doesn't try to find out why.**
>
> Anonymous

 LASSIE COME HOME
Dir. Fred M. Wilcox (1943)

Lassie Come Home was based on a novel by Eric Knight about a family who has to sell a son's beloved Collie after falling on hard times. Lassie escapes from her new owners and overcomes extraordinary obstacles to find her way home. Hundreds of dogs auditioned for the part of Lassie, but the winner was a male Collie named Pal. Eric Knight commented that they hadn't been able to find a female that looked right for the part, but at least Pal had a long thick coat that covered his manhood! All of the dogs that have since played the role of the female dog Lassie have been male Collies.

VET: Now you see, I have to interpret what the dog's moaning about.

LUCKY: What's to interpret, there's a thermometer, it's in my butt!

 ### DOCTOR DOLITTLE
Dir. Betty Thomas (1998)

Sam, the dog-shelter mutt turned actor, did not win the role of Lucky on looks alone. He is exceptionally intelligent, which enabled him to give an utterly believable performance as a talking dog in this tale of a doctor who has the ability to talk to animals. Sam also had to contend with the on-set tensions caused by Eddie Murphy's deep distrust and nervousness around animals of all kinds.

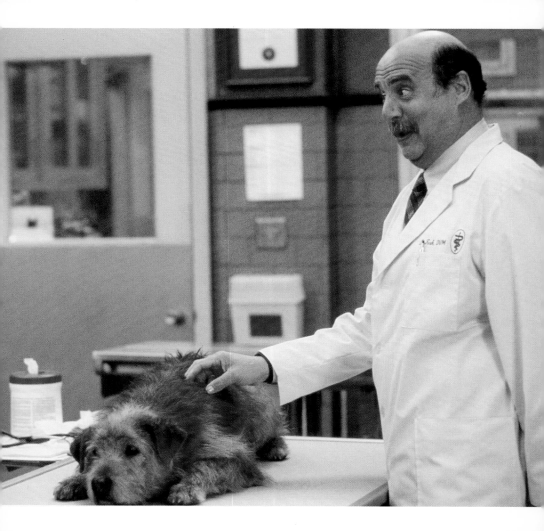

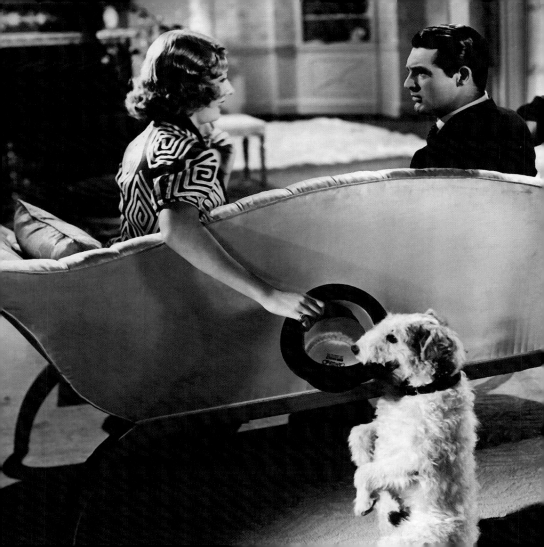

He only does it to annoy,
Because he knows it teases.

Lewis Carroll

 THE AWFUL TRUTH
Dir. Leo McCarey (1937)

The divorce case between Jerry and Lucy Warriner in *The Awful Truth* hinges on the custody of their dog Mr. Smith (played by Wirehaired Fox Terrier Asta). The judge decides to let the dog choose his owner, but Lucy cheats by showing him his favorite squeeze toy that is hidden in her muff. A little squeaky mouse was also used by Asta's trainers—and the lead actors—to get him to follow their commands. Asta was rewarded with plenty of crackers and other treats for complying, but he never got the mouse.

> No one has ever won an Oscar playing opposite a dog, especially a dog with a trainer, an agent, and a motor home— and who also takes meetings.

Charles Grodin

 BEETHOVEN'S 2ND
Dir. Rod Daniel (1993)

Filming two adult St. Bernards (Beethoven and his new love Missy) and four puppies over eight months was a project rife with challenges. A succession of puppies of various ages were relayed to and from breeders, while five St. Bernards, a full-sized mechanical dog, and a man in a St. Bernard costume were all needed to portray the puppies' parents.

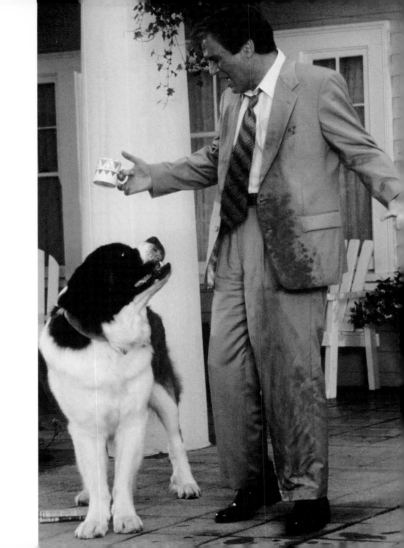

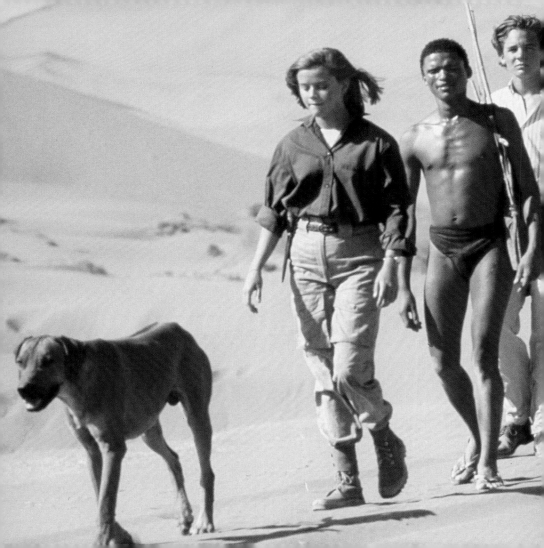

His faithful dog shall bear him company.

Alexander Pope

 ### A FAR OFF PLACE
Dir. Mikael Salomon (1993)

Hintza, the devoted dog in this odyssey tale set in South Africa, was played by Percois Patch of Shagara, a champion pedigree Rhodesian Ridgeback. Eight months of filming with Disney was enough for Percois, who then retired from show business with no further desire for stardom. He now lives quietly with his owners in Africa, but can still be persuaded to show off the tricks he learned for the movie now and then.

ANNIE: Hey, you're all right. I didn't do nothing any decent person wouldn't have done. Dumb dog.

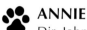

ANNIE
Dir. John Huston (1982)

The role of the stray dog Sandy was extended for this movie version of the classic Broadway musical. Two new songs were written for Annie to sing to her beloved mutt—in "Dumb Dog," she tries to shoo him away, and in "Sandy," she voices her appreciation of her new-found friend. Aileen Quinn, who played Annie, also had plenty of experience of acting with dogs before she met her canine co-star, having been the "Swing Orphan"—the child who understudied *all* the other parts—in the Broadway musical.

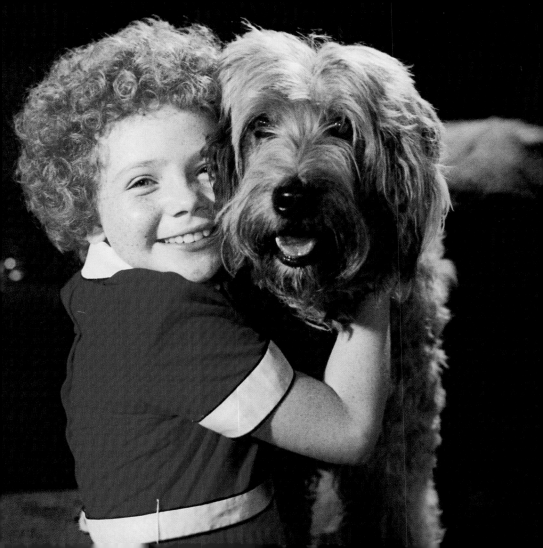

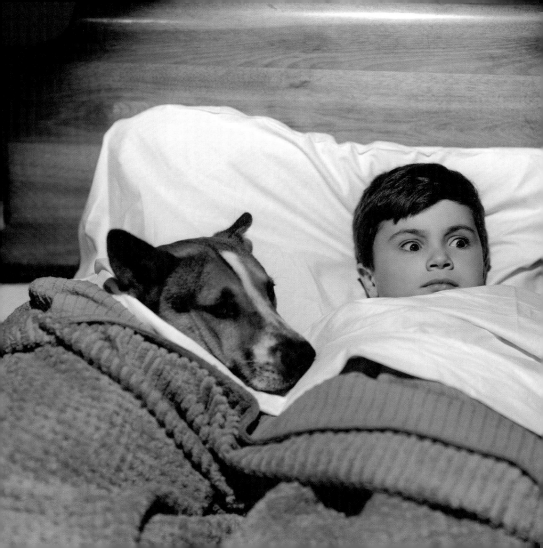

Those who sleep with dogs will rise with fleas.

Italian proverb

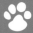 **MOKEY**
Dir. Wells Root (1942)

Mokey, played by Robert Blake (who later achieved fame as TV Detective *Baretta*), is shown here huddled up for comfort with his best pal after the death of his mother. Robert Blake was no stranger to acting with dogs. He had played opposite Petey the Bulldog for six years as Mickey in the *Our Gang* comedies, and he then went on to co-star with Rin Tin Tin, Jr. in *The Return of Rin Tin Tin*.

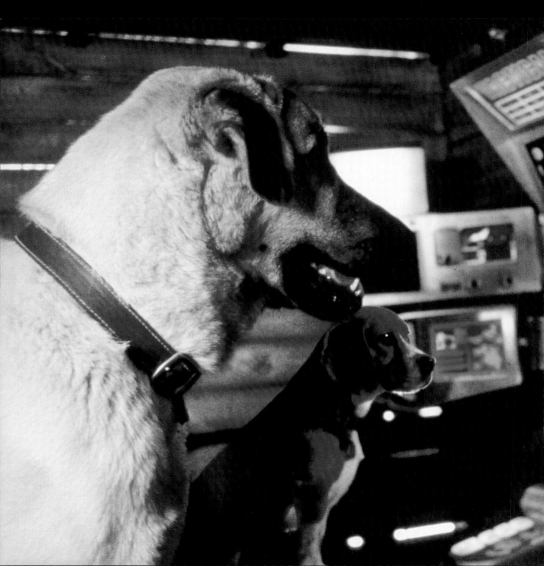

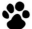 CATS & DOGS
Dir. Lawrence Guterman (2001)

In this, the first "Great War of the Pets," Butch, Chief of the dog agents, is charged with training and counseling the new agent, Lou the Beagle. Butch is an Anatolian Shepherd dog, a powerful, mastiff-like breed that has been used to guard cattle herds in Turkey for centuries. The Antolian Shepherd is a loyal, steadfast, and courageous dog that tends to be very protective of its family and territory. The filmmakers decided that these qualities made him the ideal choice to play the vital role of Lou's friend and mentor.

> # I am His Highness' dog at Kew;
> # Pray tell me, sir, whose dog are you?

Alexander Pope

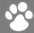 ### EVERY DAY'S A HOLIDAY
Dir. A. Edward Sutherland (1937)

When Mae West's character, Peaches O'Day, creates the glamorous alter ego Mademoiselle Fifi for herself, her elegant Doberman Pinscher is an essential part of her disguise. This beautiful dog makes a perfect lady's pet in the movie, but he was also a perfect animal actor. Doberman Pinschers are credited as one of the most intelligent and obedient breeds of dog, making them an excellent choice for filmmakers needing animal actors who will obey commands the first time.

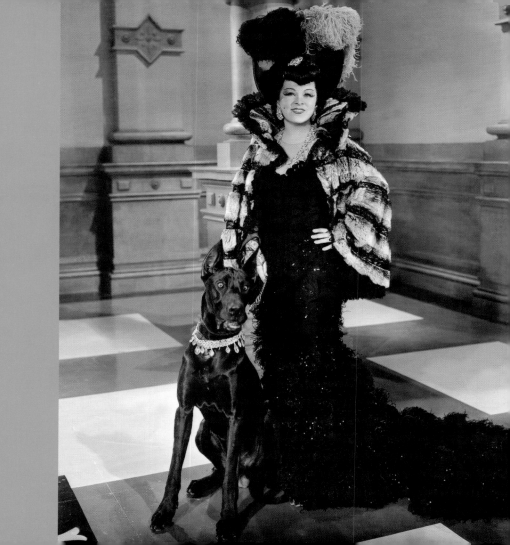

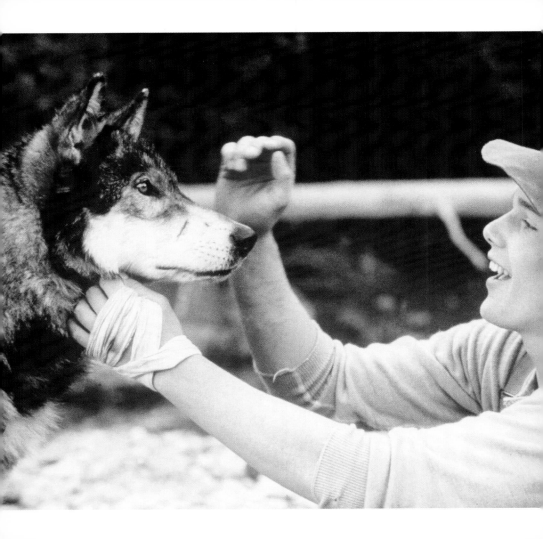

> He was squatting down on his heels, face to face with White Fang and petting him— rubbing at the roots of the ears, making long, caressing strokes down the neck to the shoulders... And White Fang was growling responsively, the crooning note of the growl more pronounced than ever.

Jack London

 WHITE FANG
Dir. Randal Kleiser (1991)

In this movie of Jack London's classic tale, White Fang was played by Jed, who is himself half-dog, half-wolf. The gritty action of the tale would be ruined for anyone who watched Jed "acting." For instance, when White Fang is seen lunging and growling ferociously, Jed is really playing with a bone. When the savage wolves bare their teeth, they are actually responding to their trainers commanding, "Teeth!", and when they set upon the body of a rabbit, it is, in fact, a mixture of dog food and chicken.

COACH: This is a joke! I mean... dogs don't play basketball!

ARTHUR: What's the matter? You afraid your team might get beat by a dog?

COACH: Put him in!

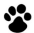 **AIR BUD**
Dir. Charles Martin Smith (1997)

When he rescued a filthy and starving Golden Retriever from the woods near his home, trainer Kevin DiCicco had no idea that the stray dog would make them both stars. Kevin played catch and fetch with Buddy the dog to get him back into shape, and it quickly became clear that he had a phenomenal gift for basketball! No clever camera trickery or optical effects were needed when Disney made this true story into the movie *Air Bud*—Buddy the dog really could shoot baskets, and he loved every minute of it!

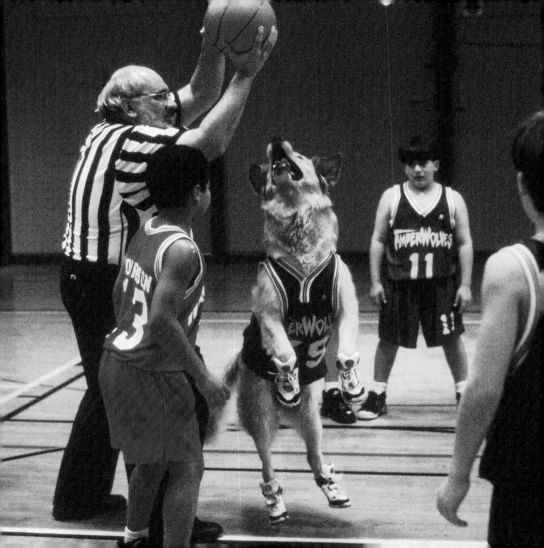

> **Friends are as companions on a journey, who ought to aid each other to persevere in the road to a happier life.**
>
> Pythagoras

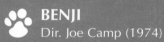

BENJI
Dir. Joe Camp (1974)

Diminutive mutt-actor Higgins soared from pound puppy to TV star in *Petticoat Junction* and then gracefully retired. However, at 15 years of age, he was coaxed back to big-screen superstardom as Benji, "America's most huggable hero" (pictured here with girlfriend and traveling companion Tiffany). Higgins made several million dollars before retiring and passing his most famous role on to his daughter Benjean.

> If a dog will not come to you after having looked you in the face, you should go home and examine your conscience.

Woodrow Wilson

 LITTLE NICKY
Dir. Steven Brill (2000)

When Lucifer's son Little Nicky (played by Adam Sandler) journeys to Earth, he is guided through the danger zones of New York City by a Bulldog called Beefy. Three bulldogs played Beefy—Roo, a tubby three-year-old; Harvey, a sensible seven-year-old; and Harley, a bouncy two-year-old female. Adam Sandler was so taken with his Bulldog co-stars that he adopted one of Roo's puppy relations and named him Meatball.

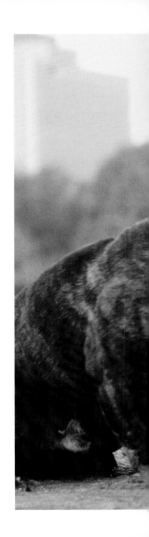

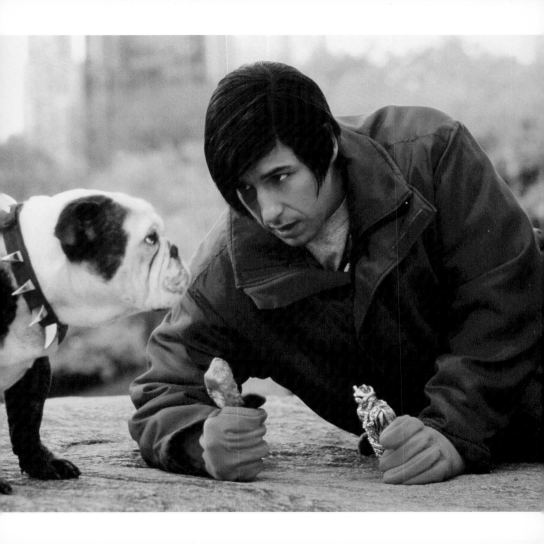

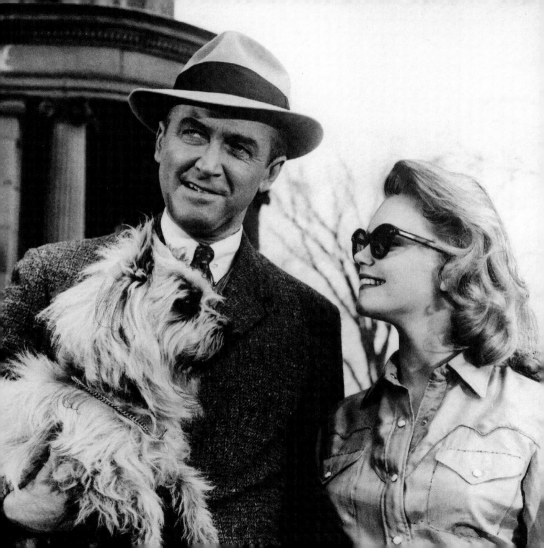

Take the tone of the company that you are in.

Lord Chesterfield

 ANATOMY OF A MURDER
Dir. Otto Preminger (1959)

Before his rather passive role as Muffy, Lee Remick's furry accessory in *Anatomy of a Murder*, Cairn Terrier Danny (here gallantly carried by James Stewart) had been trained for the role of Little Ricky's dog, Fred, on the Lucille Ball sitcom *I Love Lucy*. Danny was owned by the legendary animal trainer Frank Inn, and he also appeared in the movies *Pal Joey* and *Dennis the Menace*.

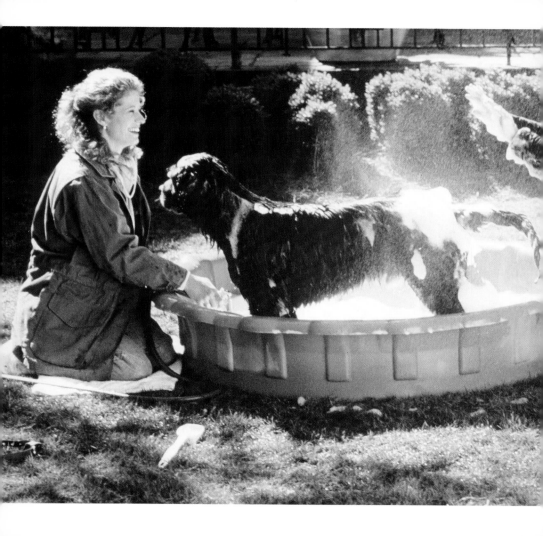

The most affectionate creature in the world is a wet dog.

Ambrose Bierce

 FLUKE
Dir. Carlo Carlei (1995)

When ambitious executive Tom Johnson is killed in a car crash, he is reincarnated as an abandoned puppy called Fluke and reunited with his loving family. Shot largely from a dog's-eye viewpoint, the story of Fluke is superbly portrayed by dog TV star Comet, a beautiful Golden Retriever. Comet was dyed brown and turned into a shaggy mongrel, all for the sake of his art.

Partners in survival. Friends for life.

Tagline from the movie

 FAR FROM HOME: THE ADVENTURES OF YELLOW DOG
Dir. Phillip Borson (1995)

Four Labradors and one animatronic dog contributed their individual skills to the role of Yellow, the intelligent dog who helps his stranded teenage owner to survive in the American wilderness. The role was mostly played by dog-actor Dakota, who was described by the cast and crew as "an immensely appealing dog." Unfortunately, Dakota's loveable nature caused problems during the filming of the wolf scenes, because the wolf refused to growl at him. Dakota had to be temporarily replaced by Tyler, an Airedale-mix that the wolf disliked.

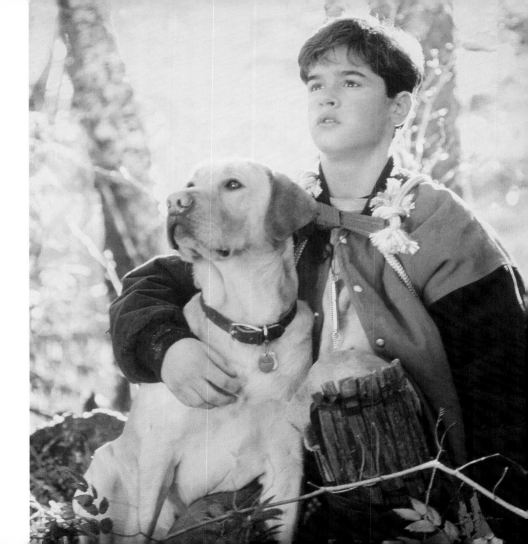

What counts is not necessarily the size of the dog in the fight——it's the size of the fight in the dog.

Dwight D. Eisenhower

 ROCKY II
Dir. Sylvester Stallone (1979)

Butkus, the Bull Mastiff who appears in the first two *Rocky* movies, is Sylvester Stallone's own dog of the same name. The success of *Rocky* made both the owner and dog huge stars, but it also kept the pair together. It was only when he had sold his script for *Rocky* that Stallone could afford to keep his dog. He had been about to sell Butkus because he didn't have the money to feed him when the deal was made.

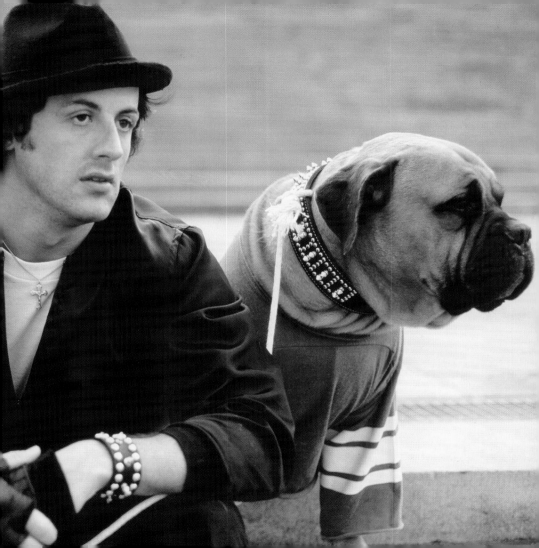

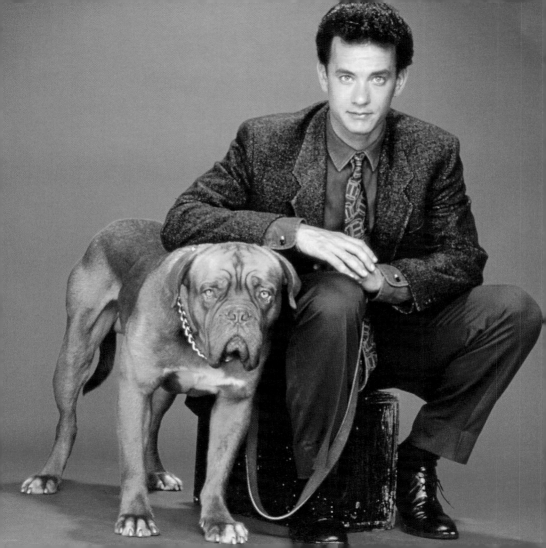

The oddest couple ever unleashed.

Tagline from the movie

 TURNER AND HOOCH
Dir. Roger Spottiswoode (1989)

Turner, played by Tom Hanks, is a clean-cut cop in every sense. Everything he owns and does is impeccably clean, until murder witness Hooch, played by dog-actor Beasley, comes into his life and slobbers all over it. Beasley is a Drogue de Bordeaux, an extremely rare dog in filmmaking terms (although Mel Gibson also played opposite one in *Payback* in 1999). Beasley is enchantingly ugly, with more folds than a Bloodhound and more wrinkles than a Mastiff. Reviewers have pronounced Beasley to be "a great actor" and said his performance was "Oscar-caliber."

If a picture wasn't going very well, I'd put a puppy dog in it.

Norman Rockwell

 FUNNY FACE
Dir. Stanley Donen (1957)

The little Yorkshire Terrier that makes a brief appearance in the Paris photo shoot scene in *Funny Face* delighted Audrey Hepburn so much that her husband Mel Ferrer gave her one of her own shortly after filming finished. Hepburn christened the dog Famous, and the two were virtually inseparable during the shooting of her next movie, *Love in the Afternoon*. Famous was just the beginning of Hepburn's love affair with Terriers, and she later owned five Jack Russell Terriers named Missy, Tuppy, Penny, Piceri, and Jackie.

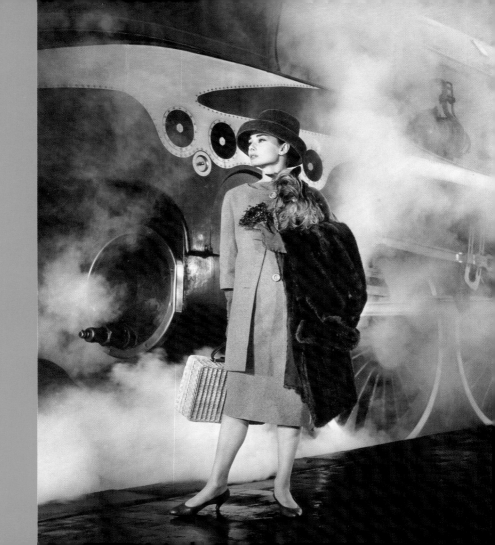

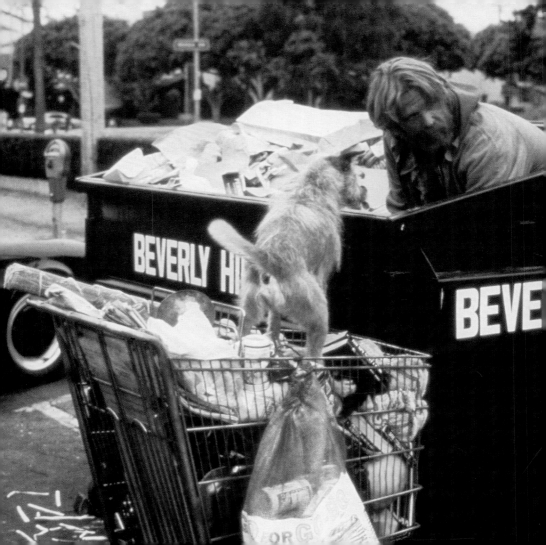

BARBARA: He's going to give that dog fleas.

 ### DOWN AND OUT IN BEVERLY HILLS
Dir. Paul Mazursky (1986)

Matisse, played by Mike, must be one of the most neurotic dogs ever seen on screen—he even gets sent to a doggie psychiatrist when he refuses to eat! Tramp Jerry Baskin (played by Nick Nolte) eventually convinces Matisse to eat by getting down on his hands and knees and eating the dog food himself. It is rumored that Nick Nolte actually ate dog food for the filming of this scene!

When we see a soul whose acts are all regal, graceful, and pleasant as roses, we must thank God that such things can be...

Ralph Waldo Emerson

THE EGYPTIAN
Dir. Michael Curtiz (1954)

The producers of this adaptation of Mika Waltari's best-selling novel spared neither time nor expense in making this ancient Egyptian epic as historically accurate as possible. This included getting two purebred Salukis to play the pets of Baketamon, the Pharaoh's sister. These elegant and graceful hunting dogs were the "Royal Dogs of Egypt." They were cherished by their noble owners and were even elaborately and expensively mummified—much like the Pharaohs themselves—when they died.

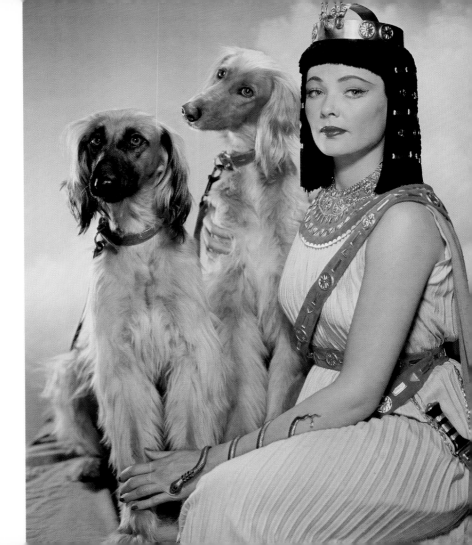

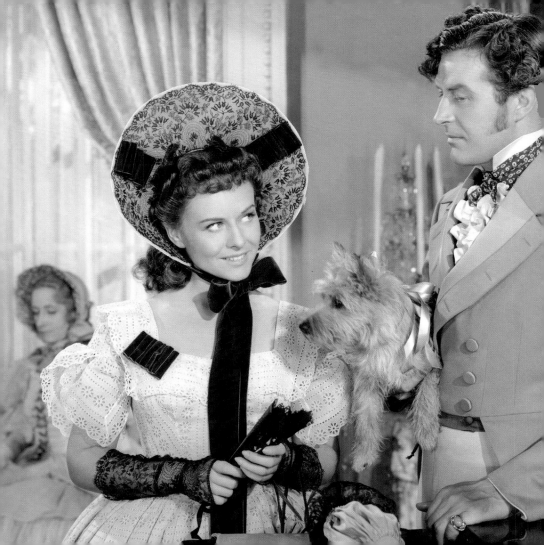

Love me, love my dog.

John Heywood

 REAP THE WILD WIND
Dir. Cecil B. DeMille (1942)

Director Cecil B. DeMille spotted Cairn Terrier Rommy, while he was still a puppy, in animal trainer Frank Weatherwax's car. DeMille immediately told Weatherwax to start training the dog because he had a part for him in his forthcoming movie *Reap the Wild Wind*. Rommy appeared in several movies after this debut and, in addition to being his trainer's favorite dog, he also became tremendously popular with his co-stars. Humphrey Bogart once pronounced Rommy "the best actor in Hollywood."

Everyone needs a spiritual guide: a minister, rabbi, counsellor, wise friend, or therapist. My own wise friend is my dog. He has deep knowledge to impart. He makes friends easily and doesn't hold a grudge. He enjoys simple pleasures and takes each day as it comes. Like a true Zen master he eats when he is hungry and sleeps when he is tired.

Gary Kowalski

 ## MICHAEL
Dir. Nora Ephron (1996)

Two reporters investigating rumors of a bona fide archangel, Michael, (played by John Travolta) learn to believe in miracles again when Michael brings their dog Sparky back to life after he is run over by a truck. Despite the movie's star-studded cast, many critics gave Jack Russell Terrier Sparky their vote for best actor. However, some puzzled crew members noted that, for most of his role, Sparky simply had to be a good dog—to stand on his mark until his trainer cued him to move, and then move.

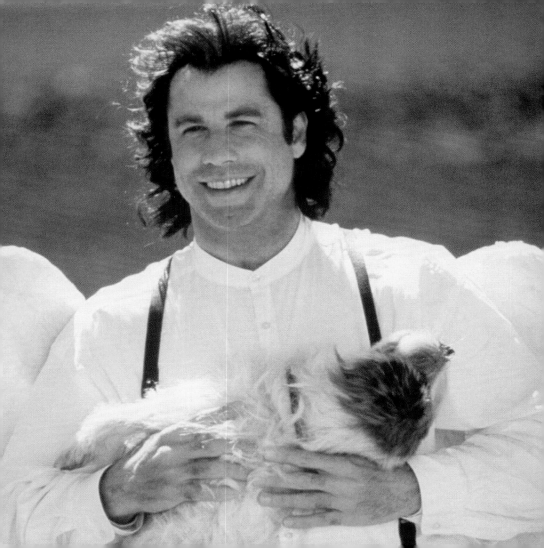

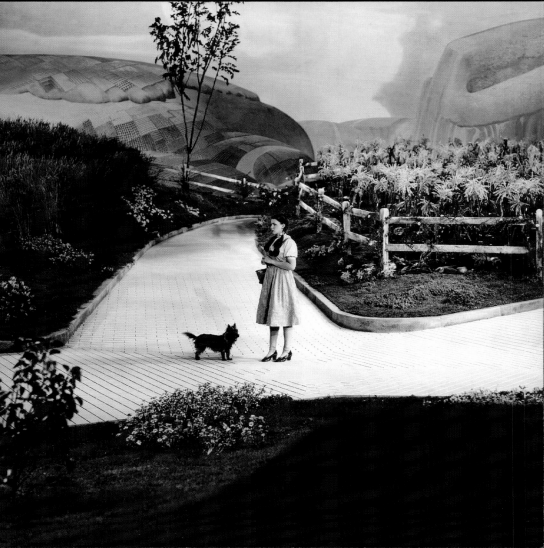

It was Toto that made Dorothy laugh, and saved her from growing as gray as her other surroundings. Toto was not gray; he was a little black dog, with long silky hair and small black eyes that twinkled merrily on either side of his funny, wee nose. Toto played all day long, and Dorothy played with him, and loved him dearly.

L. Frank Baum

 ## THE WIZARD OF OZ
Dir. Victor Fleming (1939)

Dorothy's beloved pet Toto, played by Cairn Terrier Terry, is one of Hollywood's most famous movie dogs, and she even has her own autobiography: *I, Toto: The Autobiography of Terry, the Dog Who Was "Toto."* Terry was so important to the movie that she was paid more than some of the human actors—she earned $125 per week, whereas the Munchkins were only paid $50. She was even granted a two-week holiday during filming, after one of the wicked witch's soldiers accidentally stepped on her.

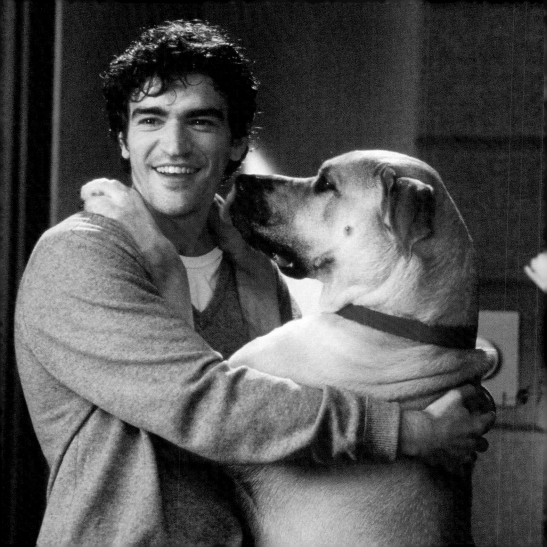

ABBY BARNES: We can love our pets, we just can't LOVE our pets.

THE TRUTH ABOUT CATS AND DOGS
Dir. Michael Lehmann (1995)

Great Dane Hank is responsible for bringing together the two romantic leads in this movie when he becomes agitated after being fitted with a pair of roller-skates for a photo shoot. The real Hank, however, was very comfortable wearing the roller-skates to film this hilarious scene, because he had three months of slow, careful training to prepare him for it. The filmmakers made special skates for the dog, and for most of the scene, he only moved when his trainer pulled him along using hidden leads attached to his skates.

> He will kiss the hand that has no food to offer; he will lick the wounds and sores that come in encounters with the roughness of the world… When all other friends desert, he remains.
>
> George G. Vest

JAWS OF STEEL
Dir. Ray Enright (1927)

By the time this drama—in which Rin Tin Tin protects a baby girl from many dangers, thereby proving that he is not a vicious killer—was released, dog-actor Rinty was already a megastar. Warner Bros. introduced him to the public in 1923 and his success saved them from serious financial problems. Rinty was rewarded with a salary of $1,000 a week and such perks as a diamond-studded collar, Chateaubriand steak for breakfast, and his own personal mood-music orchestra.

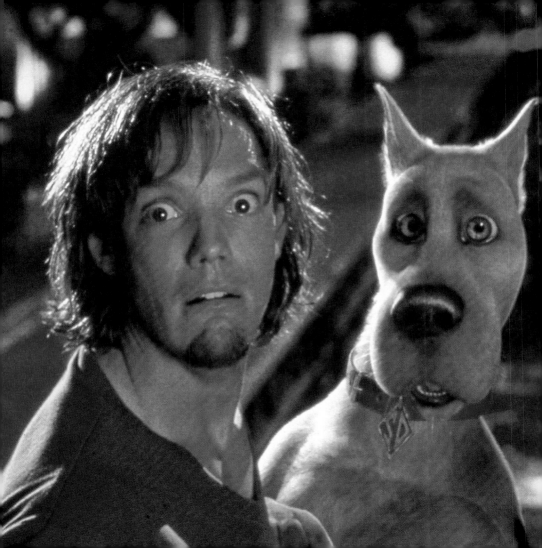

SHAGGY: Like chill out, Scooby-Doo, stop shaking.

SCOOBY DOO: Me? That's you!

SHAGGY: Oh right it's me, sorry.

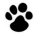 ### SCOOBY DOO
Dir. Raja Gosnell (2002)

In the original *Scooby-Doo* cartoon series, Scooby-Doo was a large, loveable, and cowardly Great Dane who solved crimes with a bunch of high-school students known as the Mystery Inc. Gang. The series was modeled on *The Famous Five* books created by Enid Blyton, which are about a gang of four mystery-solving children and their mongrel dog, Timmy. For the 2002 movie version, the cartoon characters came to life—all except for Scooby-Doo, who morphed into a Computer Generated Image.

DEMON THE HUSKY: Ted, my main man, you really stepped in it this time! We tried to tell ya you didn't belong here!

TED BROOKS: I don't speak dog.

DEMON THE HUSKY: Tell me about it!

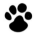 **SNOW DOGS**
Dir. Brian Levant (2002)

The eight Siberian Huskies in this movie are more than a match for Cuba Gooding, Jr. in the acting stakes. However, it is really thanks to computer wizardry that the dogs can wink, grin, raise their eyebrows, and bat their eyelashes, since Huskies' expressions tend to be rather non-committal. *Au naturel* dog acting is very labor intensive, and just getting the dogs to look out a window required each of the eight dog trainers to be in a position from where he could give hand and voice cues to get *his* dog to look in the right direction.

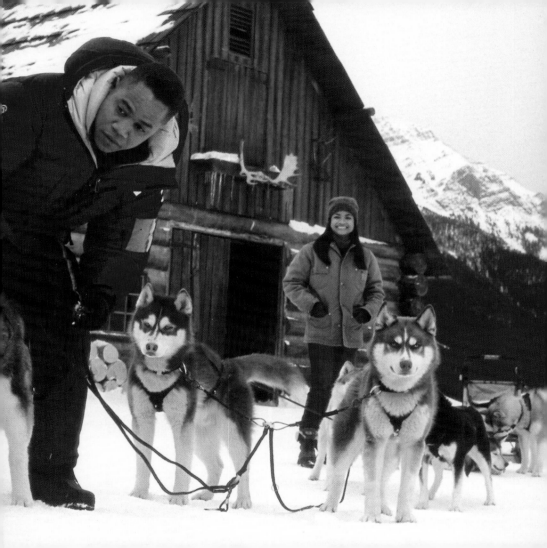

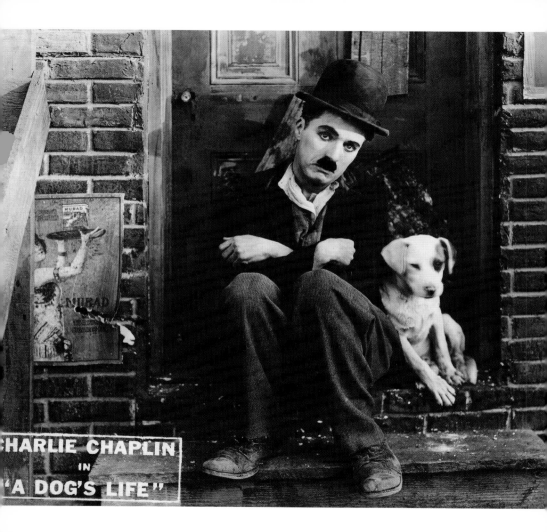

CHARLIE CHAPLIN
IN
"A DOG'S LIFE"

> ## The poor dog, in life the firmest friend
> ## The first to welcome, foremost to defend.
>
> Lord Byron

 ### A DOG'S LIFE
Dir. Charlie Chaplin (1918)

This bittersweet comedy reveals how closely the life of a tramp, played by Charlie Chaplin, mirrors that of his dog Scraps, played by Mutt. Studio reminiscences tell how Mutt grew from a pup into a dog during filming. A pup-sized double could not be found, so oversized props and diminishing camera angles had to be used to get around this development.

> We are all strong enough to
> bear the misfortunes of others.
>
> La Rochefoucauld

 ### PEG O' MY HEART
Dir. Robert Z. Leonard (1933)

Marion Davies played a young Irish girl sent to England to learn to be a lady in this drama. The snooty English relatives Peg has to stay with make the mistake of trying to part her from her only friend, Michael, played by dog-actor, Mutt. Their close relationship in the movie was equalled by the affection they felt for one another off set. When not filming, Marion and Mutt romped together famously and Marion was heard to voice strong disapproval of any reviews that failed to credit Mutt.

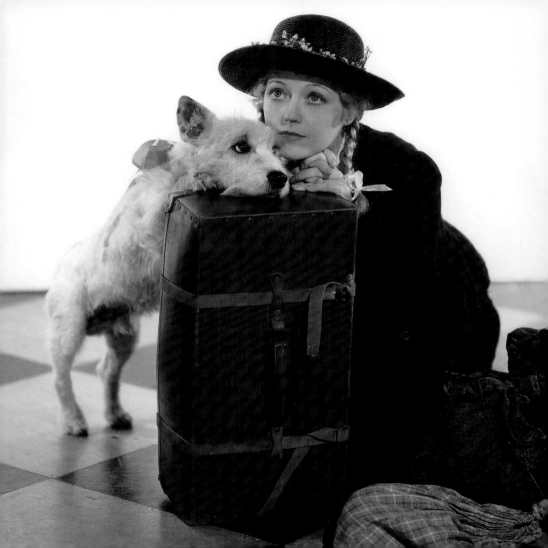

Photo Credits

All images are courtesy of the Kobal Collection.

Text Credits

p.10: Dialogue from *Men in Black II* (Amblin Entertainment/Columbia Pictures/MacDonald/Parkes Productions; screenwriters Robert Gordon and Barry Fanaro). p.13: Dialogue from *101 Dalmatians* (Great Oaks Entertainment/Walt Disney Pictures; screenwriter John Hughes). p.16: Extract © Dr. Ian Dunbar. p.19: Dialogue from *The Thin Man* (Cosmopolitan Films/MGM; screenwriters Albert Hackett and Frances Goodrich). p.20: Dialogue from *Homeward Bound: The Incredible Journey* (Touchwood Pacific Partners/Walt Disney Pictures; screenwriters Caroline Thompson and Linda Woolverton). p.26: Tagline from *K-9* (Gordon Company/Universal Pictures). p.28: Dialogue from *As Good As It Gets* (Gracie Films/TriStar Pictures; screenwriters Mark Andrus and James L. Brooks). p.36: Dialogue from *Doctor Dolittle* (20th Century Fox/Davis Entertainment/Joseph M. Singer Entertainment; screenwriters Nat Mauldin and Larry Levin). p.40: Extract from *How I Get Through Life* by Charles Grodin (William Morrow & Co., 1992). p.44: Dialogue from *Annie* (Columbia Pictures/Rastar Productions; screenwriter Carol Sobieski). p.49: Dialogue from *Cats & Dogs* (Mad Chance/Warner Bros./Zide-Perry Productions; screenwriters John Requa and Glenn Ficarra). p.54: Dialogue from *Air Bud* (Walt Disney Pictures; screenwriters Paul Tamasy and Aaron Mendelsohn). p.64: Tagline from *Far From Home: The Adventures of Yellow Dog* (20th Century Fox). p.69: Tagline from *Turner and Hooch* (Touchstone Pictures). p.73: Dialogue from *Down and Out in Beverly Hills* (Silver Screen Partners II/Touchstone Pictures; screenwriters Paul Mazursky and Leon Capetanos). p.78: Extract from *The Souls of Animals by* Gary Kowalski (Stillpoint Publishing, 1999). p.83: Dialogue from *The Truth About Cats and Dogs* (20th Century Fox/Noon Attack; screenwriter Audrey Wells) p.87: Dialogue from *Scooby Doo* (Atlas Entertainment/Hanna-Barbera Productions/Mosaic Media Group; screenwriter James Gunn). p.88: Dialogue from *Snow Dogs* (Galapagos Productions/Walt Disney Pictures; screenwriters Jim Kouf, Tommy Swerdlow, Michael Goldberg, Mark Gibson and Philip Halprin).